Animals
That Help Us

Horses

Jean Coppendale

QED Publishing

Words in **bold** can be found in the Glossary on page 23.

A catalogue record for this book is available from the British Library.

ISBN 978 1 84538 667 2

Written by Jean Coppendale
Designed by Melissa Alaverdy
Editor Paul Manning

Publisher Steve Evans
Creative Director Zeta Davies
Senior Editor Hannah Ray

Picture credits
Key: t=top, b=bottom, l=left, r=right, c=centre, FC=front cover
Alamy: p7 tr View Stock; p13 ct Günter Gollnick; p14 bl
Adrian Sherratt; p20 cl The Geoff Williamson Image Collection.
Corbis: contents page Tom Brakefield; p4 bl Thierry Charlier/
Sygma; p4-5 Lindsay Hebberd; p6-7 David Stoecklein; p8-9
Dan Lamont; p9 cb Elder Neville/Sygma; p14-15 Ron Watts;
p18-19 Graham Tim/Sygma; p19 tr Tim Thompson; p20-21
Larry McDougal; p22-23 Steve Chenn. Getty Images: p10
Graham Robertson/Reportage; p12-13 Johner/Johner Images.
©RDA: title page, p16-17, p17 tl. Rex Features: p10-11:
JB/Keystone USA.

Printed and bound in China

Contents

How horses help us

Horses help us in many ways. They work on farms, in forests and on busy city streets. Some horses are specially trained to help disabled children to learn how to ride. Horses also take part in parades and entertain us at shows. Different types of horses do different jobs.

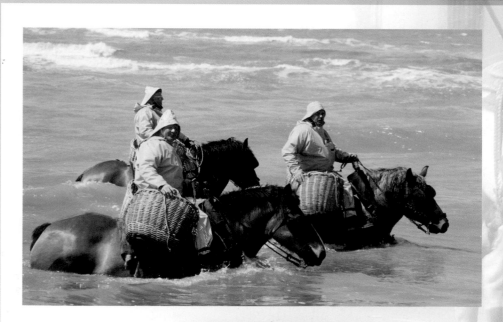

These horses are helping fishermen to catch shrimps off the coast of Belgium.

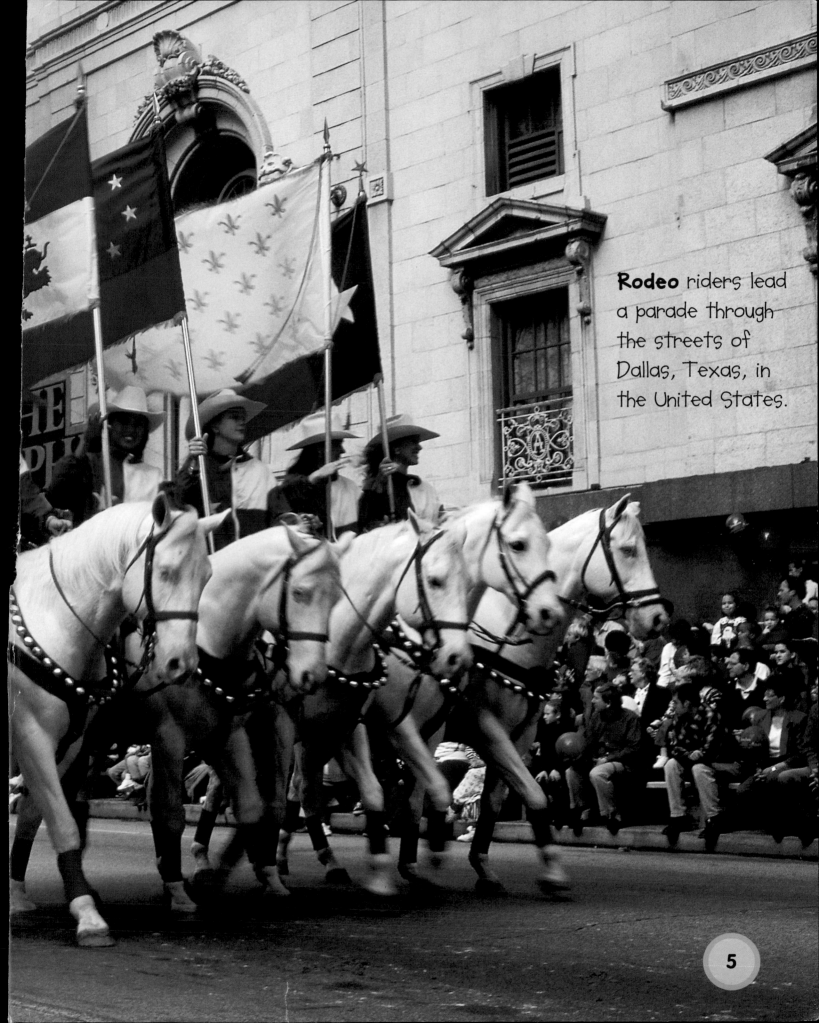

Rodeo riders lead a parade through the streets of Dallas, Texas, in the United States.

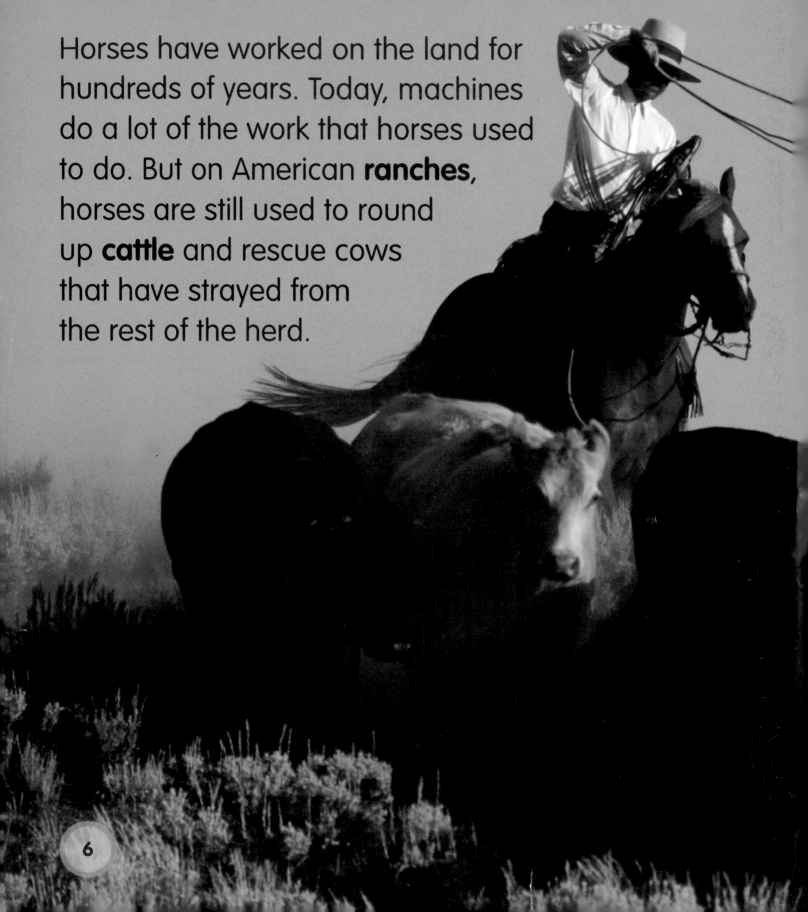

Horses on the land

Horses have worked on the land for hundreds of years. Today, machines do a lot of the work that horses used to do. But on American **ranches**, horses are still used to round up **cattle** and rescue cows that have strayed from the rest of the herd.

An American **cowboy** uses a **lasso** to round up runaway cattle.

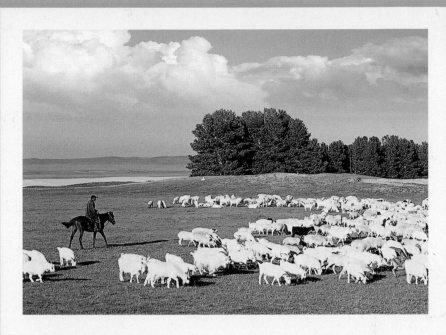

In parts of Scotland, farmers still round up sheep on horseback.

Horsepower!

In forests and woodland, strong horses are often used instead of tractors to pull heavy loads. This is because people enjoy working with horses, and horses do not do as much damage to the land.

When trees have been sawn up, the horses drag the logs through the forests to the road, where the logs are loaded onto trucks.

A tug on the reins will give this powerful working horse the signal to start pulling its heavy load.

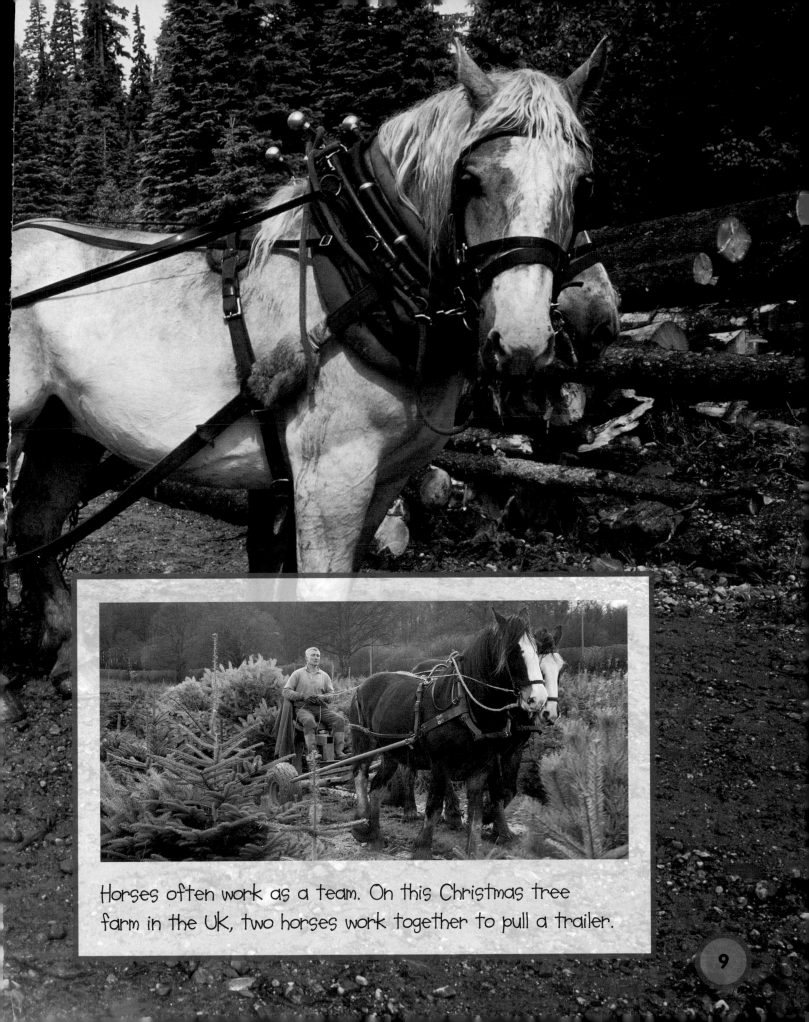

Horses often work as a team. On this Christmas tree farm in the UK, two horses work together to pull a trailer.

Police horses

In many countries, horses help to keep city streets safe. Police officers who ride horses are called mounted police. Horses help to control crowds at parades, big meetings and sports events. They are also used to **patrol** the streets. Police officers can see a lot more when they are on a horse than when they are on foot.

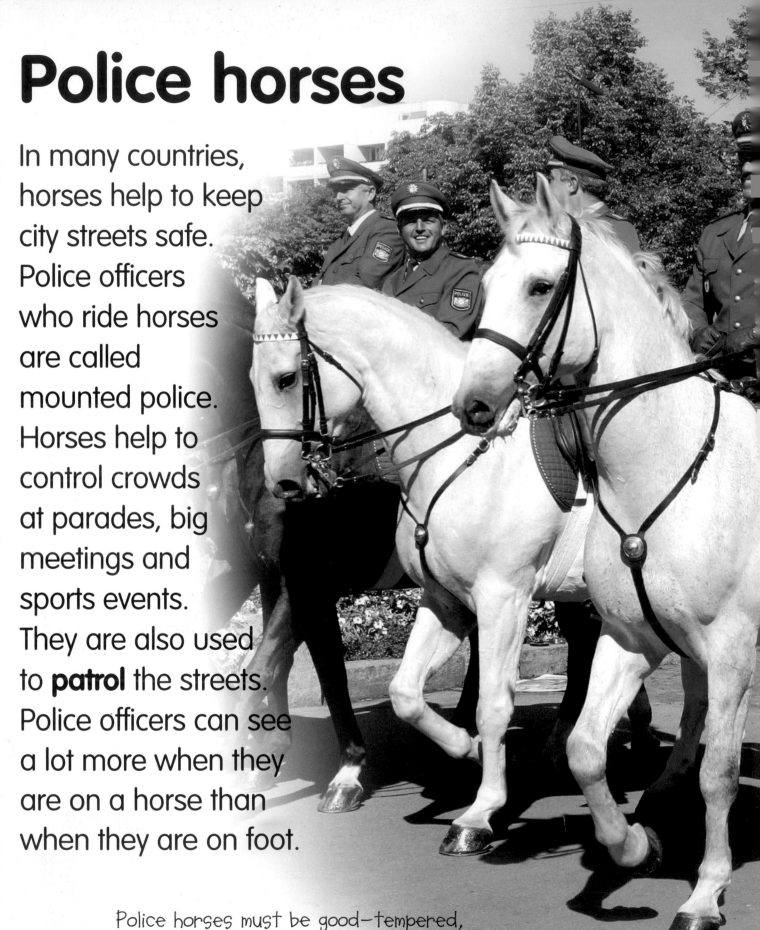

Police horses must be good-tempered, patient and friendly, as well as strong.

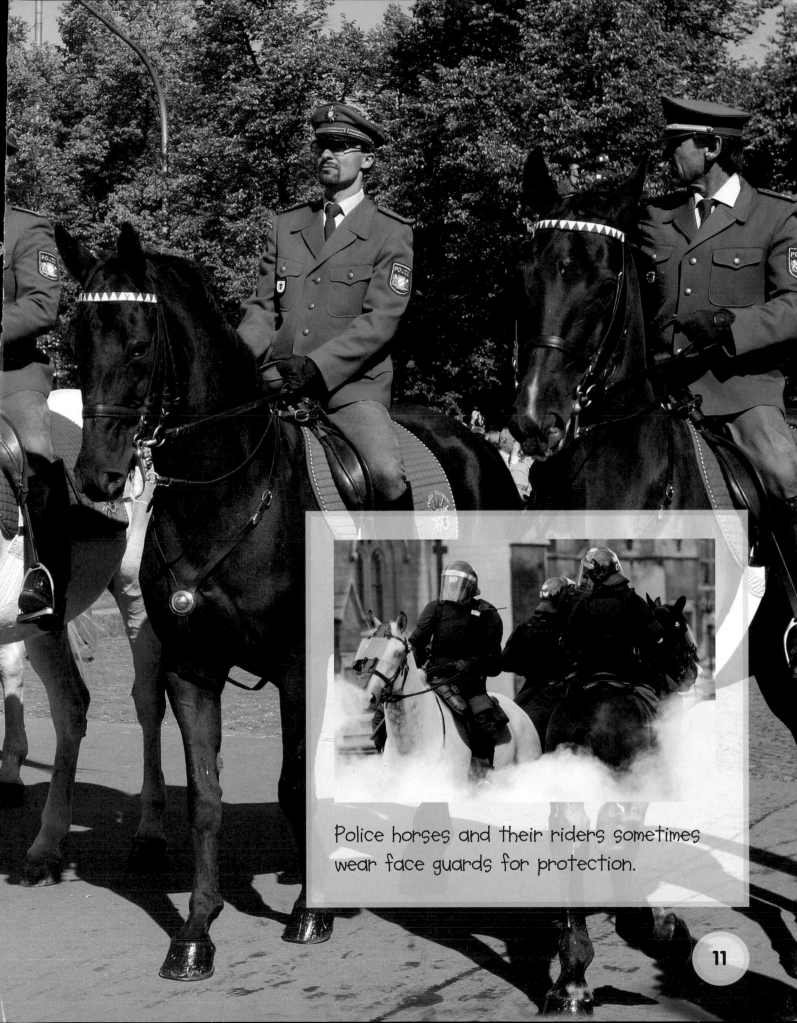

Police horses and their riders sometimes wear face guards for protection.

Wedding horses

In some countries, beautiful horses take the bride to the church in a white carriage. Sometimes the horses wear **garlands** of flowers, bells and other brightly coloured decorations. After the wedding ceremony, the horses and carriage take the bride and **bridegroom** to the wedding party.

White horses are often chosen to pull wedding carriages. The correct term for a 'white' horse is a 'grey'.

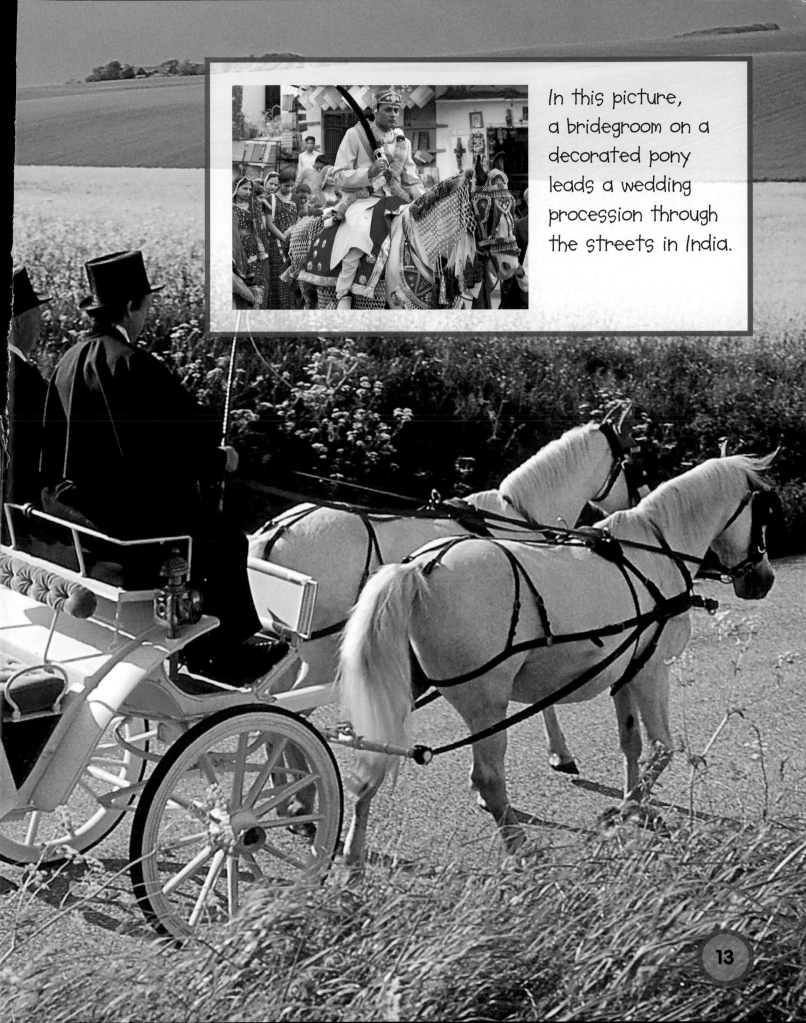

In this picture, a bridegroom on a decorated pony leads a wedding procession through the streets in India.

Holiday horses

Horses can make our holidays more special. In some big cities, visitors can hire a horse and buggy for a **sightseeing** tour.

Many people also enjoy riding in the country or **trekking** on horseback through beautiful countryside. Riding a horse is much healthier and more fun than riding in a car!

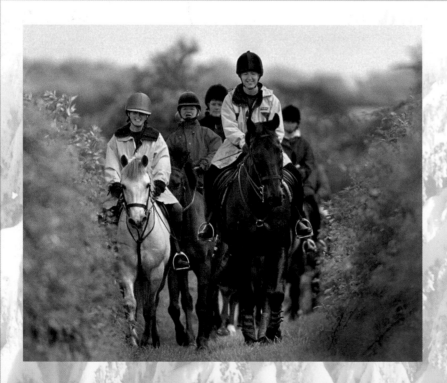

Riding is a great way to make friends and explore new places.

The horses enjoy the fresh air and exercise, too.

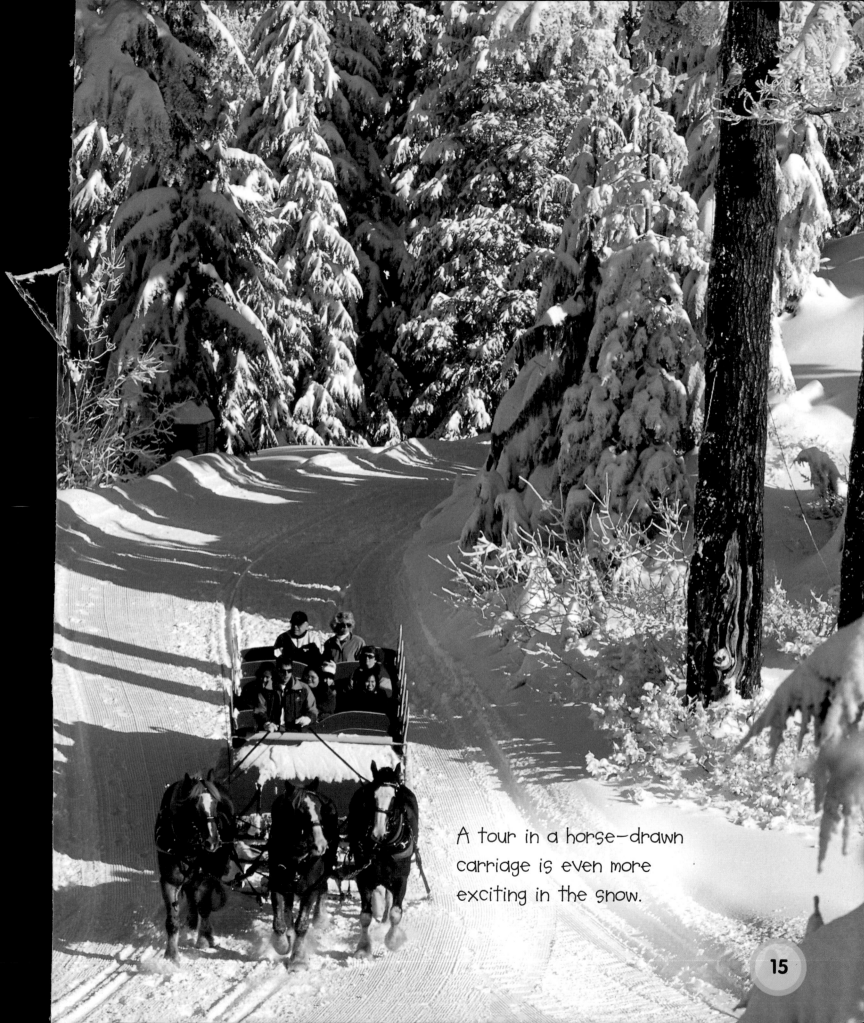

A tour in a horse-drawn carriage is even more exciting in the snow.

Horses on parade

In London, huge crowds gather every year for the Trooping of the Colour. This is a grand display to mark the Queen's birthday, when military bands and soldiers on horseback parade past Buckingham Palace.

In Canada, the Royal Canadian Mounted Police (the 'Mounties') put on a special display every year. The riders and their horses perform to music and end with an exciting **gallop**.

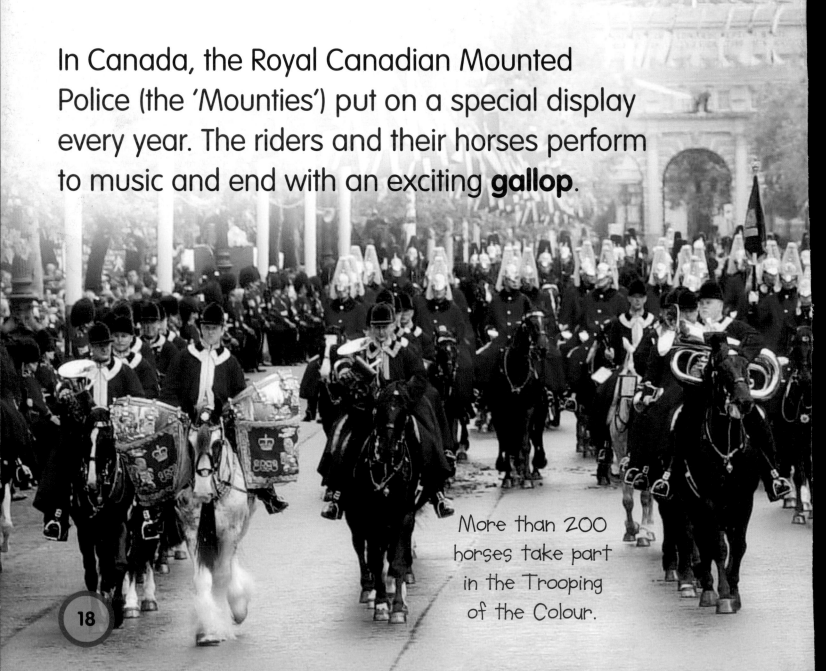

More than 200 horses take part in the Trooping of the Colour.

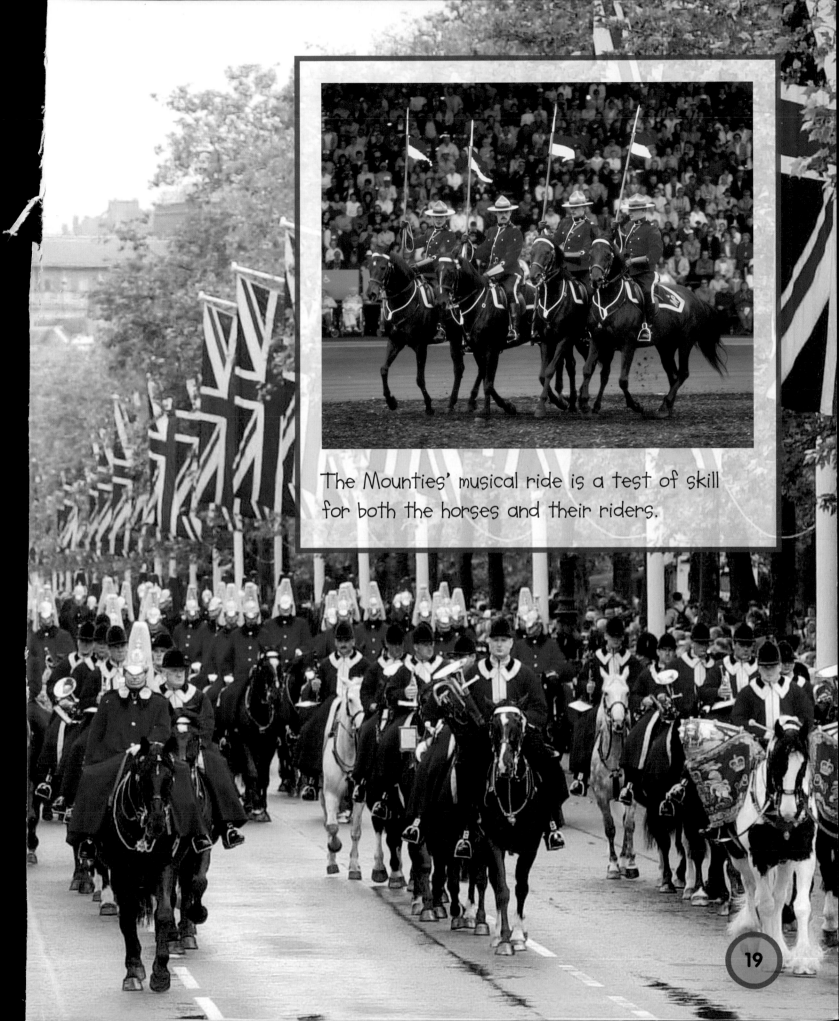

The Mounties' musical ride is a test of skill for both the horses and their riders.

Show horses

Horses take part in many different shows and events all over the world. In the UK, a gymkhana is a riding competition which is often organized by the local pony club. Events include jumping, **dressage** and races.

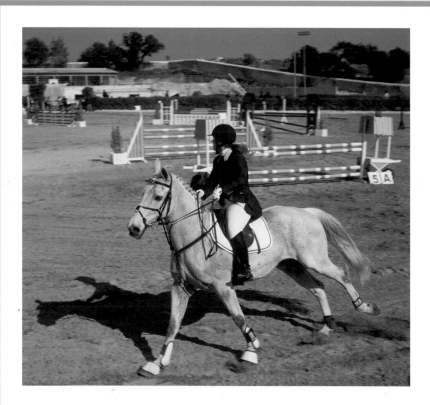

In showjumping, a rider who jumps all the fences successfully scores a 'clear round'.

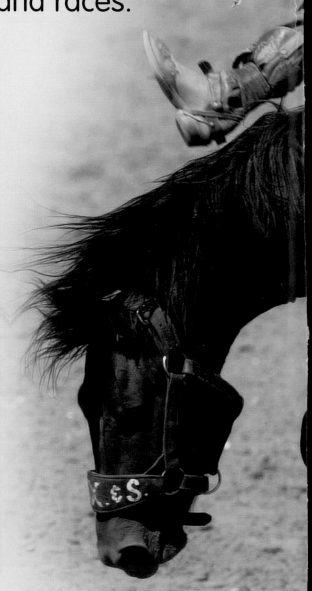

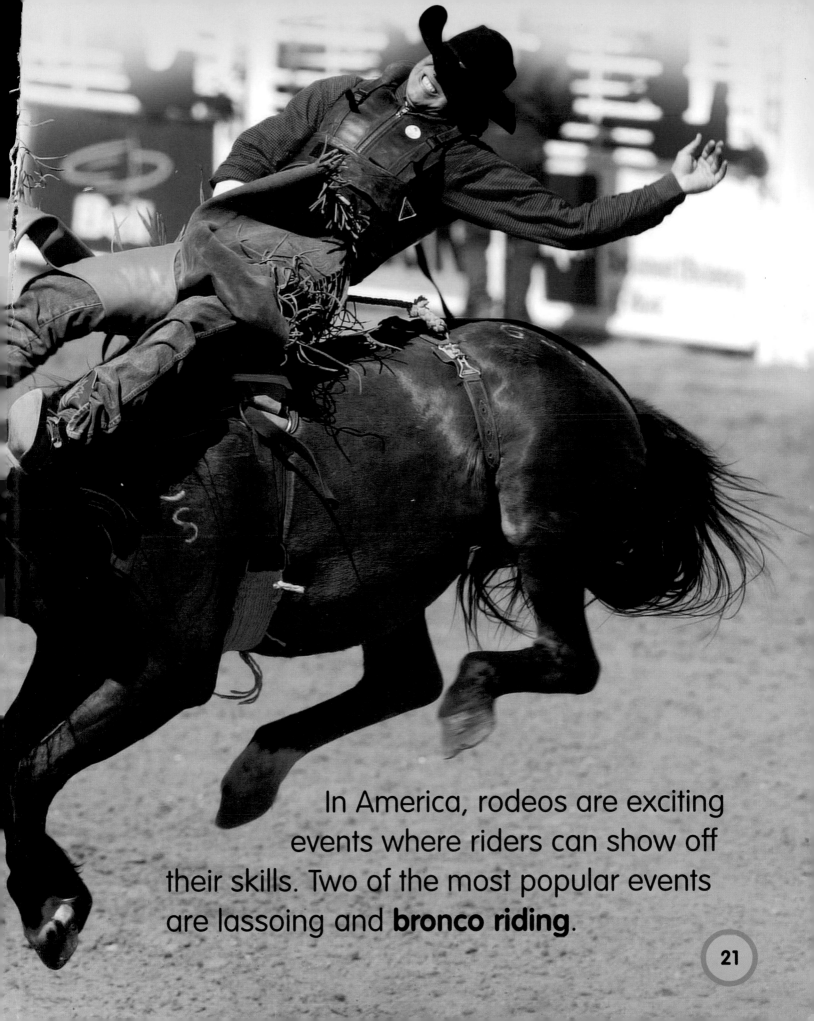

In America, rodeos are exciting events where riders can show off their skills. Two of the most popular events are lassoing and **bronco riding**.

Activities

- Imagine you are one of the horses from this book. Which horse would you like to be? Why? Make up a story about your day as this horse and draw a picture.

- What sort of work do you think this horse would do: police work, or pulling heavy loads?

- Make a collage of a horse. Collect scraps of material for its coat, pieces of wool or string for its mane (the thick hair on the back of its neck) and shiny paper for its hooves.

- Make a horse scrapbook. Collect pictures of horses from magazines and newspapers and paste them into a sketchbook with notes on what they do. Try to include as many different types of horse as possible, from police horses to Indian wedding horses.

Glossary

bridegroom
a man who has just been married or is about to be married

bronco riding
riding a wild or partly trained horse without a saddle

cattle
a group or herd of cows

cowboy
an American farm or ranch worker

dressage
a set of movements which test a rider's skill and control over their horse

gallop
a fast horseback ride; the fastest a horse can go

garland
a necklace woven from flowers

lasso
a length of rope with a loop at one end, used to catch cattle

patrol
to walk or ride round an area to make sure everything is safe

ranch
a farm in America where cattle or horses are reared

rodeo
a popular event in America where cowboys show off their riding skills

sightseeing
visiting special places of interest

trekking
travelling on horseback through mountains, desert or beautiful countryside

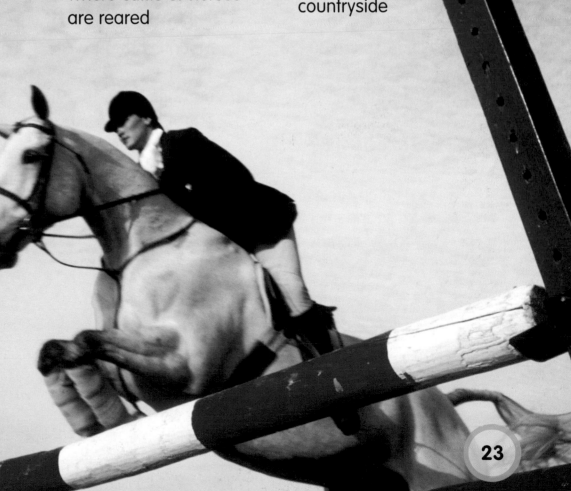